MISERICORDS

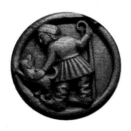

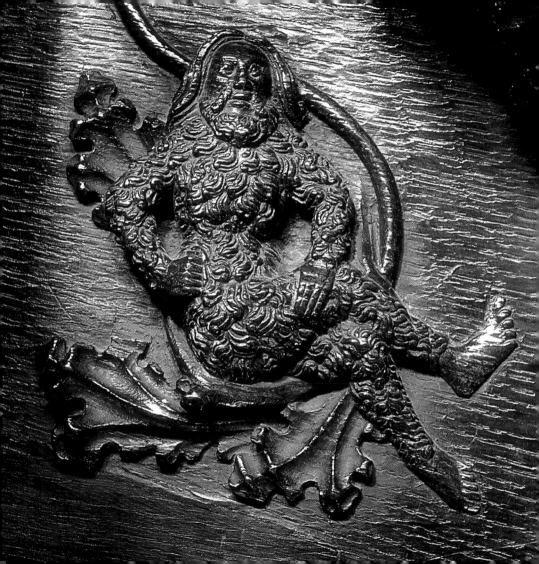

A LITTLE BOOK

OF

MISERICORDS

Text and Photography by

Mike Harding

AURUM PRESS

Special Edition for PAST TIMES®, Oxford, England

First published by Aurum Press Ltd,
25 Bedford Avenue, London WC1B 3AT

Text and Photography copyright © 1998
Mike Harding

A catalogue record for this book is available
from the British Library.

ISBN 1 85410 562 0

Printed in Belgium by Proost

Facing title page – Wodewose supporter, Bristol
Title page – Bird holding man, Oxford
Opposite – Monster, Carlisle Cathedral

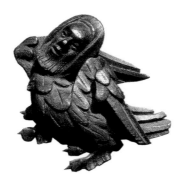

These homespun Winter's Tales
under the bums of Bishops,
worlds upside down, and turned to give
release to rheumatic monks.
Who saw them? Untangled the turvey topsy thread
of story? Canting Reynard, Samson with Gaza's gates
a kitchen punch-up and a Doctor Ape?
Did Bishops' bums have eyes to read?

Poem by the author

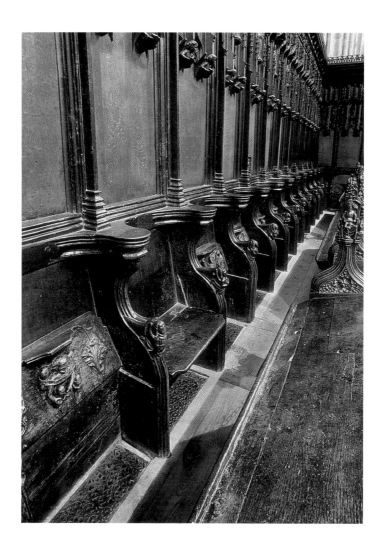

INTRODUCTION

In the preaching by means of *example* moral lessons were less often conveyed with the help of Bible stories; instead, sinning and foolishness on earth are associated with animal nature. Animal nature is the true subject matter of misericords.

Christa Grossinger – *The World Upside Down*; Harvey Miller, 1997

❖

In the choirs of many of the abbeys and cathedrals of Europe is a secret topsy-turvy world where the everyday meets the miraculous and the sacred rubs cheeks with the profane.

The misericord, a carved wooden tip-up seat, was designed to give some comfort (*misericord* from the Latin for *pity* and *heart*) to the older monks during the very long hours of service. From the eleventh to the fifteenth century, these under-seat ledges, such as those shown opposite from Ludlow, were decorated with rich, and in some cases, artistically splendid carvings. Skilfully carved from single blocks of oak, they were turned by unknown geniuses into a celebration of both the miraculous and the mundane.

The English misericords in this book tell much the same stories and show many of the same scenes as their European counterparts, but there is one difference. Only in Britain and Ireland will you find misericords with supporters, the small, often round carvings that flank the main image.

In the earliest carvings to have survived, the supporters were often simply decorated with foliage or flower heads, later they came to mirror the theme of the central plinth so that the carving of the shepherds at work from Beverley Minster (pp. 20–21) has supporters showing a shepherd and his dog on the sinister and sheep grazing on the dexter supporters.

We have no real way of knowing if the carvers were given free rein in the choice

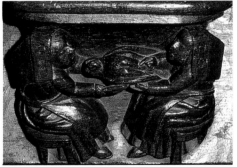

and execution of subject, but even though misericords were part of the choir stalls and very close to the altar, biblical subjects are vastly outnumbered by scenes from daily life and from the narratives of folklore and fable. Vibrant workaday scenes sit side by side with fantastic monsters and satires on the clergy and, in the spirit of ornamentation that pervaded medieval art, hidden and little-seen lumps of wood were turned into objects of great beauty. Yet why would somebody pay for such carvings if they were so rarely seen? We may also ask why, high on the exterior of many of the great cathedrals where none but the birds can see them, are beautifully cut Green Men, grotesques, gargoyles and lewd and sexual carvings. They are there perhaps simply because to the medieval mind they would be seen, if not by earthly eyes then by other, hidden eyes, perhaps by the eyes of the Almighty himself.

According to an expert on the

misericords of Chester's great Cathedral there is evidence that on certain special days of the year the laity were allowed into the inner sanctum of the choir and would then see the stories made in wood that otherwise were lost from view. Some of the carvings such as the illustration on page 11 of the Pelican in her Piety are inspired by medieval fable and legend. The pelican was thought to have fed her young with drops of blood from her breast and thus became a symbol

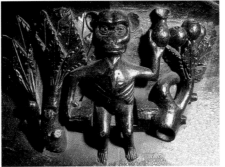

of Christ who gave his blood for the redemption of mankind.

The common people would of course delight in the domestic scenes, such as the two women opposite plucking a fowl from Fairford, and they would understand all the references in the carvings, from Alexander's flight into heaven in his basket (p. 46) and the owl in his ignorance (p. 54) to the monkey from Cartmel Priory on this page holding a flask of urine, a satire on the quack doctors who were held to be as untrustworthy as a monkey.

Bawdy and earthy, fantastical and everyday, the misericord is a celebration of legends, folk-lore, the life and the traditions of the common people, a bible, a bestiary or a book of hours carved in wood – much like the gargoyles, Green Men and other grimacing grotesques that were carved on the walls of church and abbey, the misericords of the Middle Ages have their own narrative, one that today we can often merely guess at but which can still intrigue and delight.

DOMESTIC BRAWLS

❖

Bristol Cathedral & St Mary's, Fairford

Men seem to have a hard time of it in medieval kitchens if we are to go on the evidence of the misericords, since husband battering is a favourite subject of the carvers and there are examples in many of the major collections. The example opposite is from Bristol Cathedral, that on this page from St Mary's, Fairford.

One theory is that the scene was intended to serve as a reminder to the monks that the world of marriage and domestic bliss is not without its dark side. Perhaps the truth is somewhat simpler and the scene is there not to warn off the celibate but to delight the observer with the sight of a woman getting her own back. This is a prime element of the world turned upside down that the Middle Ages seemed to celebrate so much.

The Festival of Fools and St Stephen's Day when boy bishops were waited upon by deans and cardinals lives on still in some parts of Europe in festivals like All Fool's Day in England, and in carnivals such as Germany's Oktoberfest and the Mardi Gras of the Hispanic world.

MERMAIDS

❖

Cartmel Priory, Cumbria & Bristol Cathedral

When Shakespeare had Oberon in *A Midsummer Night's Dream* (Act II, Scene i) declare:

'once I sat upon a promontory,
And heard a mermaid, on a dolphin's back,
Uttering such dulcet and harmonious breath, That the rude sea grew civil at her song…'

he was drawing on a very old tradition that had been the stuff of sea-faring legend for hundreds of years. The sea maid, like the Silkie, the seal woman of the Hebrides is a creature of the seas. Half-woman, half-fish, she has no soul though she longs more than anything else to acquire one.

On the island of Iona, smooth, perfectly round pebbles were said to be the tears of a mermaid who had begged St Columba to give her a human soul and had been denied the gift by that decidedly un-Christian saint.

The mermaid from Cartmel has two tails and holds a mirror and a comb which link her with the sirens, those beautiful creatures of Greek mythology who lured unsuspecting sailors onto the rocks.

The mermaid opposite from Bristol looks as though she is about to become dinner for a wyvern (a two-legged dragon) and a strange flying man.

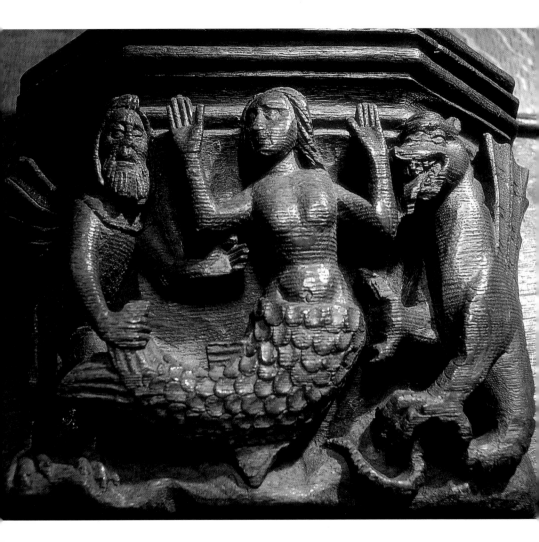

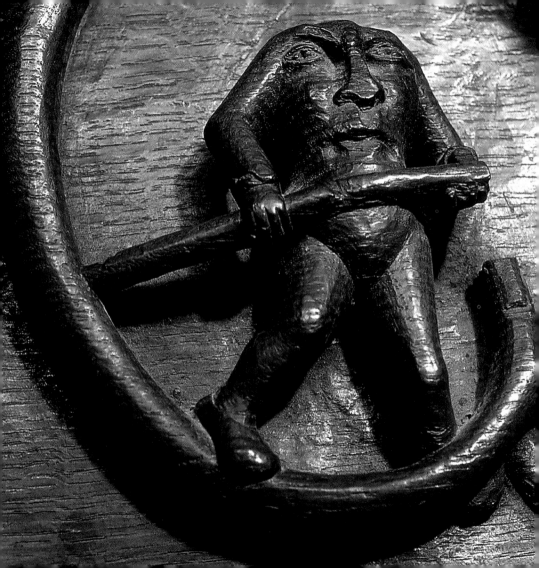

Fantastical Creatures

❖

Ripon Cathedral, North Yorkshire

Medieval merchants and seafarers exploring the new spice and silk routes into fabled far-away lands brought back with them tales of fantastical creatures, mermaids, sea serpents and the Hippocampus, a creature half-horse, half-fish.

Writers like Pliny and Herodotus had, in earlier times, added to the menagerie of strange and grotesque creatures so that the fantastic featured large in the medieval mind and, as we have peopled outer space with our own 'bug-eyed alien' creatures, the people of the Middle Ages created a world on the outer reaches where anything was possible. Pliny describes the Blemyae as an Indian race of headless creatures, six feet tall and having their eyes and mouths in their stomachs. The two you see here are particularly cheerful Yorkshire specimens.

The *Biblia Pauperum* and other books carried on this tradition of the wild and fantastic: centaurs, blemyae, mandrakes and basilisk were all part of the imaginary menagerie.

Swift was later to create a world not dissimilar to that enjoyed by the medieval mind in his satirical, fantastical novel *Gulliver's Travels.*

Shepherds at Work

❖

Beverley Minster, Yorkshire

The craftsman who created this rare misericord has achieved something truly remarkable in perfectly capturing the everyday life of the shepherd, from the rams fighting beneath the tree on the dexter supporter to a wonderful moment of tenderness between a man and his dog on the sinister roundel.

It is hard to believe that the carving is more than five hundred years old. But for the costume, you could be watching a farmer at work on a fellside in the Yorkshire Dales today.

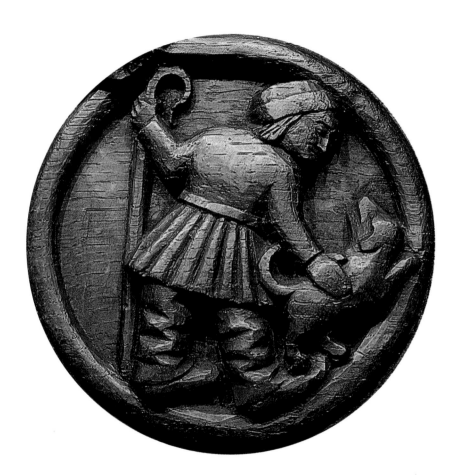

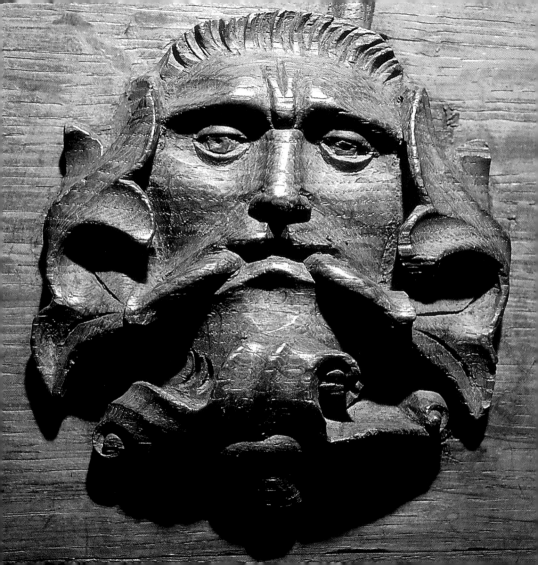

THE GREEN MAN

❖

Bristol Cathedral

Green Men appear in church carvings in three fairly distinct forms: as a face that is peering from amidst a frame of leaves – Jack in the Green, as he is often called; as a face whose skin is turning into leaves – the foliate head; and as a face with leaves coming out of the mouth in great bunches – the uttering or spewing head. The Green Men carved on roof bosses and the capitals of pillars can be any one of these three basic types. The Green Men cut into misericords however are almost all of the spewing head kind.

The two fine heads here, supporters from the choir stalls of Bristol Cathedral are beautifully carved and illustrate perfectly the central dilemma of the Green Man. What exactly do the carvings mean? The answer is that nobody really knows, though guesses are plenty. The general consensus seems to be that he is a direct descendant of the pagan tree worship prevalent in Europe before Christianity took the sacred groves and wells and turned them into sites of Christian worship. There are many Green Men in Devon in churches in villages whose names end in 'nemeton', or 'nympton', a word which designates the village as having been the site of a sacred grove.

MUSICAL PIGS

❖

Beverley Minster, Yorkshire

Music was associated by the clergy with lust and loose living. The fact that it went on, and that nothing they could ever do would prevent songs being sung and dances being danced didn't stop them preaching against it wherever possible.

The bagpipes in particular were associated with lust; whether their squeal was thought to correspond in some way to the noises medieval lovers made while in congress we will never know, but to the medieval mind the bagpipes as well as being a 'provoker of urine' were seen by the clergy as a symbol of the baser of man's instincts. The pig was also seen as a lustful and gluttonous animal and, since the bag for the pipes was made from a pig's bladder, the combination of pig and bagpipe is often a feature of the carvings of the Middle Ages.

In the delightful misericord opposite from Beverley Minster, a sow plays the bagpipes while the little piglets dance around the trough.

On this page, the happy little porker playing the harp with such an ecstatic expression on its face is the dexter supporter from the same stall.

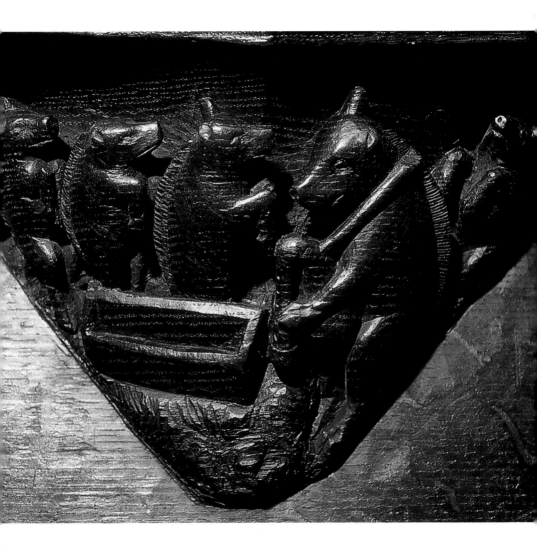

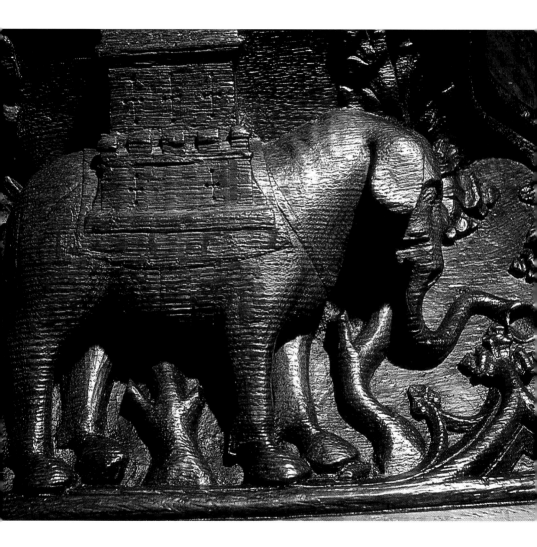

ELEPHANTS & CASTLES

❖

Gloucester Cathedral & Cartmel Priory

Elephants with castles on their backs are a favourite theme amongst misericord carvers as well as inn sign painters and elephants and castles occur amongst many sets of misericords. Crusaders returning from the wars in the Holy Land and other travellers would tell of enemy warriors going into battle on the backs of elephants, protected inside great wooden towers or castles.

According to some historians Alexander the Great had been the first to use such primitive 'tanks' in his epic campaigns and the idea had been copied by the armies of other countries. In Gloucester Cathedral the carver has carved the elephant with horse's feet, never having seen an elephant he assumed that it had feet like a horse. The same kind of feet can be found on the elephant in Bristol Cathedral. However, after 1255, carvers had no excuse for getting the feet wrong, for in that year the first elephant arrived in England as a gift to Henry III from Louis IX of France. The elephant was led in procession to the Tower of London and ever after that carvers had a true model to work from.

JONAH & THE WHALE

❖

Ripon Cathedral, North Yorkshire

The master wood carver William Bronfleet of Ripon was so successful that he became mayor of that town in 1511. Though there is no hard evidence to link him directly with the choir stalls them-selves, it is thought by many experts that Bronfleet and his assistants were responsible for the stalls at Ripon, Manchester and Beverley.

There are many stylistic similarities and subject matter and carvings are often so close as to be almost identical.

Only at Ripon however do you find the truly wonderful carvings of Samson with the gates of Gaza under his arm (see p. 65), and the two misericords showing the story of Jonah and his adventures with the whale.

In the carving opposite we have a crow's nest view of poor Jonah being thrown to the whale while in the scene on this page from the second stall the whale, complete with finely carved teeth and gills, is spewing him up again.

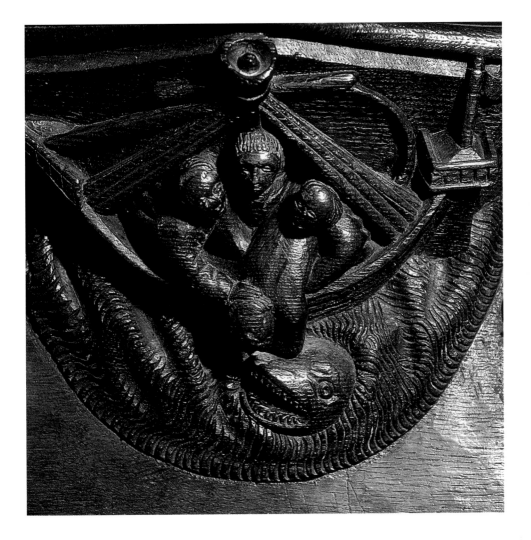

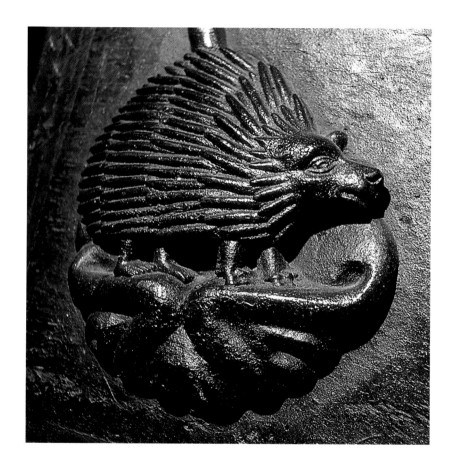

HOUND & HEDGEPIG

❖

Cartmel Priory & Chester Cathedral

The birds and animals of the countryside find their way into the misericords from time to time, but are rarely carved with such care and attention as the little 'hedgepig' on the facing page from Cartmel Priory. Every aspect, from the lovingly carved spines to the delicate small feet, has been cut in great detail. As far as I know, it is one of only two hedgehogs on misericords anywhere in Europe (the other is in New College, Oxford) and it is comforting to think of it nestling under the backsides of the venerable monks of Cartmel.

The hedgehog in medieval bestiaries is often described as a fruit stealer since it was believed that the animal would go into orchards and vineyards in the dark of night and would roll upon fallen fruit impaling it on its spikes. Then, fully loaded, it would trundle off back to its little ones with a portable larder of Cox's Pippins.

The charming little dog on this page looking up adoringly is from Chester Cathedral and represents, to the medieval mind, courage and fidelity.

Dragon-Slaying Angels

❖

St Andrew's, Greystoke & Carlisle Cathedral

Possibly showing St Michael thrusting Satan down to Hell, the finely carved misericord from Greystoke, opposite, is one of a particularly handsome set of robustly carved stalls. The church itself seems over large for the village it serves, for Greystoke, a few

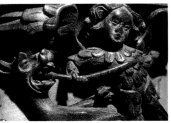
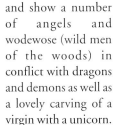

miles west of Penrith, is a small untroubled hamlet in a placid green backwater.

The church, however, was a collegiate church and before the dissolution of the monasteries the monastery would have had a fair number of chapels and dormitories and would have been home to several hundred monks and collegians.

The misericords are well preserved and show a number of angels and wodewose (wild men of the woods) in conflict with dragons and demons as well as a lovely carving of a virgin with a unicorn. Carlisle Cathedral, another haven for misericord hunters has the angel and dragon on this page; a wonderfully vibrant and powerful example of the woodcarver's art, the feathered archangel Michael rams home the spear while the dragon looks decidedly unhappy about the whole affair.

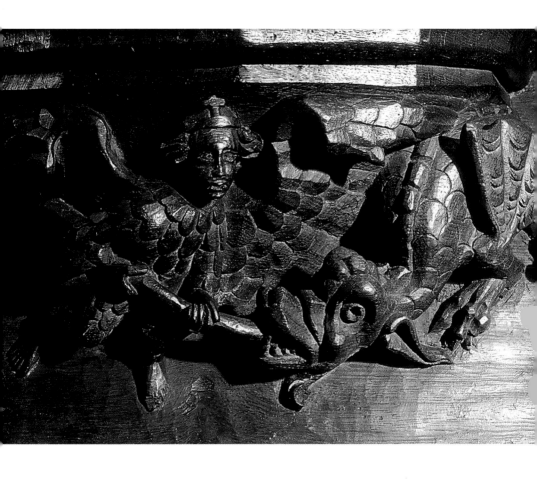

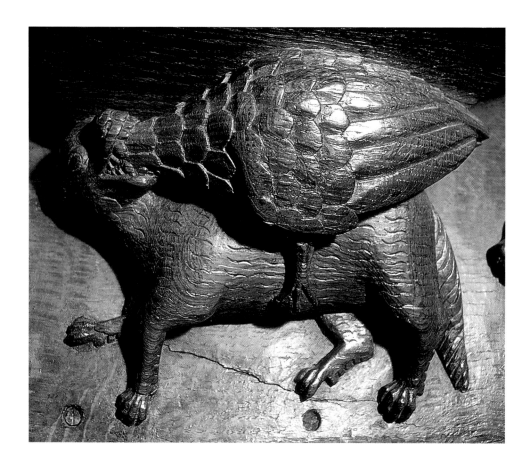

Fox & Goose

❖

Ripon Cathedral & Winchester Cathedral

Perhaps one of the most popular subjects of all with the carvers who made the misericords was the fox running off with the goose. The old folk song 'Daddy Fox' tells us that:
*'Old Mother Whipper Whapper
jumped out of bed,
And out of the window stuck her head,
John John the Goose is gone,
And the fox is on the town.'*

It is a fair guess that the song comes to us across the ages from some medieval fireside.

The fine carving opposite from Ripon shows old Reynard with his head turned in a lovely curve. Above, in the misericord from Winchester, the housewife with her distaff tries to head him off while the dog looks doubtful about chasing the much bigger fox.

THE WRATH OF GRAPES

❖

Fairford, Gloucester

Boozing figures quite largely in the set of misericords in St Mary's, Fairford. In the carving on this page a man is shown sleeping off the effects of drink, while opposite, two men are about to get outside of a cask of ale. Though scenes of daily life abound in medieval choir stalls, it is rare to find a set so devoted to drinking and eating.

The carvings are especially fine, the wood a light golden colour rather than the dark black, polished oak to be found in the choir stalls of Cartmel Priory and Manchester Cathedral.

This celebration not just of the ordinary but of what could be seen perhaps as the sinful and carnal side of life seems to the modern mind out of place in a church, but five hundred years ago there was no such separation of life into the sacred and profane, and the medieval mind saw lessons and morality in everything. From the boozer sleeping off his drink on the kitchen floor to that other common image of the fox preaching to the gullible and unsuspecting geese, every image had a narrative and every story had a moral.

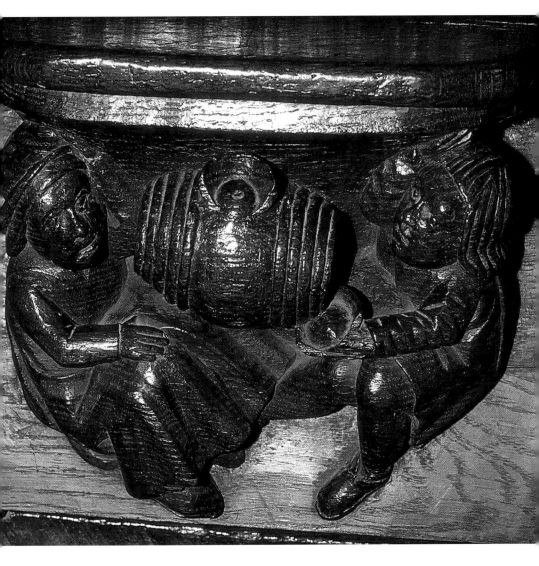

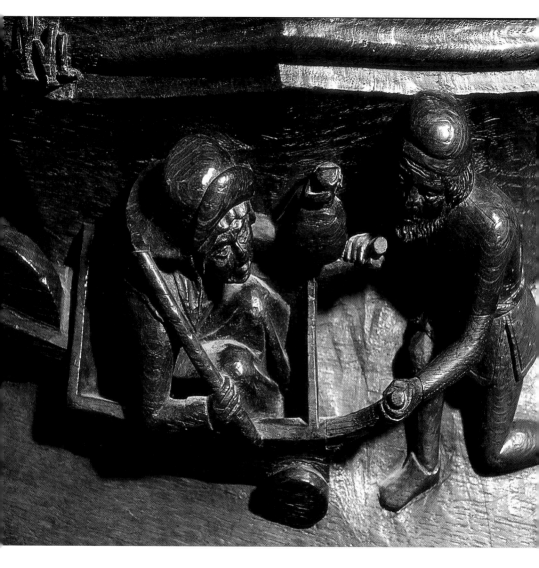

THE WORLD UPSIDE DOWN

❖

Ripon Cathedral & Whalley Abbey

On St Stephen's Day the world was officially turned upside down and in the spirit of carnival the Lord of Misrule reigned supreme.

Boy bishops were elected in the cathedrals, abbots waited at table upon the lowest of their order and, for that day at least, the moral and 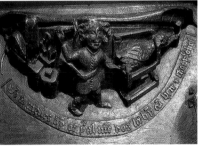 temporal order of the world was reversed.

This love of the surreal, the mocking of the assumed order of things, may well have acted as a safety valve in a society which was bound not just by temporal law but by the laws of the church and which needed, from time to time to 'let down its hair'.

The carving from Ripon on the facing page shows a man wheeling his wife in a barrow; she is drunk and is on her way back from the festival. The image appears originally in a German woodcut.

The scene on this page from Whalley shows a smith trying to shoe a goose and the inscription reminds us that meddling in other people's business is as much use and just about as sensible.

SIRENS

❖

Winchester College & Lincoln Cathedral

The woman serpent opposite with wings and what has been identified as a north African horned viper for a tail comes from a fine set of misericords in the stalls of Winchester College. The significance of the carving is now lost to us and we can only wonder at its meaning, although it appears in the bestiaries as an amphisbaena, a creature with a second head in its tail and thus capable of moving in two opposite directions.

Another example can be found in the stalls in the cathedral of St Mary, Manchester. Likewise the figure on this page from Lincoln Cathedral would appear to be an amalgam of a queen, a swan and a dragon.

Defined by scholars as sirens, Greek mythology tells us that these creatures were originally river goddesses who resisted the power of love and were transformed into half-birds, half-women by Aphrodite as a warning to all who would thwart the goddess of love. They went on to have their feathers plucked out by the Muses and ended up stuck on a rock singing to sailors.

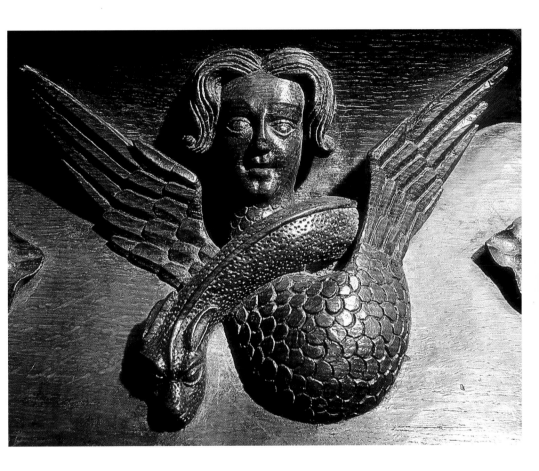

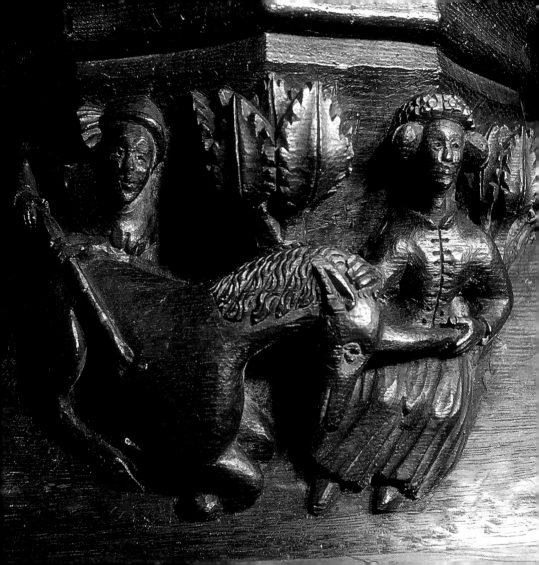

UNICORNS

❖

St Andrew's, Greystoke & Cartmel Priory

The classical writer Solinus tells us that the unicorn is '...*headed like a Stagge. His horn sticketh out of the midds of his forehead, of a wonderful brightness about four foote long, so sharp, that whatsoever he pusheth at, he striketh through it easily. He is never caught alive; killed he may be, but taken he cannot be.'*

Solinus perhaps embroidered the writings of Pliny who, in the first century AD, borrowed the story from Ctesias, Alexander the Great's physician, who had seen the wild asses of the Indian Himalayas.

By the Middle Ages the unicorn had a mythology all of its own. Its horn was said to purify water and other animals would wait for it to dip it into pools before coming down to drink. The lovely little carving on this page from Cartmel shows it doing just that. The easiest way to capture a unicorn was for a virgin to sit quietly in the forest. The unicorn, entranced by a creature as pure as itself, would come and lay its head in her lap, at which point the hunter could come and kill it, as seen in the carving opposite from Greystoke.

Folk Tales

❖

Worcester & Bristol Cathedrals

One of the most interesting medieval stories tells of the wise daughter who solves a riddle posed by a king in which he promises their weight in gold to anyone who can come to him clothed and yet naked, neither riding nor walking and bearing a gift that is no gift. She therefore wears a net, keeps one foot on the ground and carries a hare as a present which will of course escape as soon as it is given.

The Bristol misericord opposite shows a scene from the Reynard the Fox stories, a series of tales popular all over medieval Europe. Tybalt the cat has been sent to bring the cunning Fox to justice. Along the way, he is tricked into the house of the Priest's mistress and trapped. The Priest's son has Tybalt by the neck, while the cat has the priest by the testicles; the game thus would appear to be in a checkmate situation.

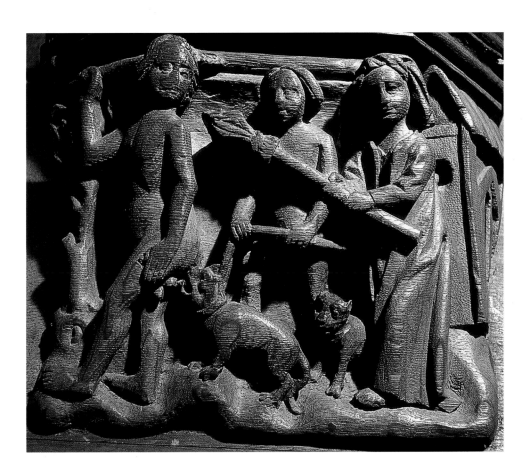

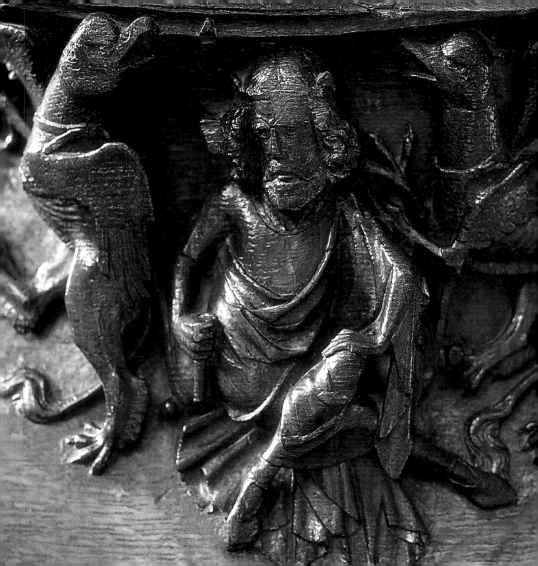

Medieval Legends

Wells & Chester Cathedrals

Alexander the Great, his conquests and his wars are subjects that feature large in the storytelling traditions of many of the cultures of Europe and have even travelled as far as the mountains of Pakistan.

He was a historical figure and lived from 356 to 323 BC, though he eventually became surrounded by more myth than truth. One story tells of how Alexander, once having conquered the whole world, decided to fly above the Earth to see what lay beyond. He set off in a basket hauled by two eagles (in some versions he is hauled aloft by a pair of gryphons). The carving on this page from Chester shows another of the

great stories of the European tradition. The two illicit lovers Tristan and Iseult here meet in the woods, traditional trysting place of lovers in the days of chivalry. The little dog at their feet laps the water in the pool on the edge of which they stand, thus destroying the reflection of the jealous King Mark who peers at them from his hiding place. It is said that the carving of Alexander represents the sin of pride, that of the lovers, lust.

BAWDY CARVINGS

❖

Bristol Cathedral

Writers like Chaucer and Rabelais had no problem with the earthy and the bawdy, any more than those anonymous makers of folk music who created such songs as 'The Bonny Black Hare' where the hunter's quarry is not in truth the hare but something that is bonny, black and covered in hair.

Chaucer's *Miller's Tale*, as every school child knows, is bawdy and scatological and has been ignored since Victorian days by those who set the texts for school examinations. This same spirit of prudishness brought about the destruction and removal of most of the sexual church carvings in these islands and it is rare to find a set of misericords as devoted to the carnal and the bawdy as those in Bristol Cathedral.

Yet there is nothing crude or distasteful in the carvings. Adam and Eve and all the other nudes in the stalls look very jolly and comely. Even Tybalt hanging from the priest's testicles (p. 45) looks funny rather than fearsome or horrific.

The supporter above shows a man caught with his pants down, that on the page opposite has drawn forth various interpretations. I have no intention at all of adding to them.

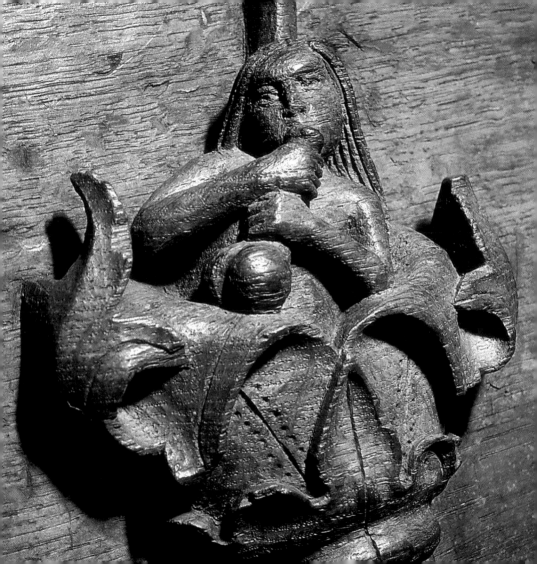

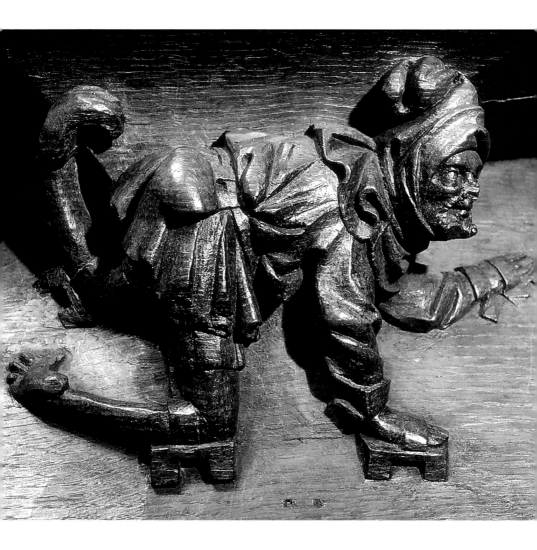

CRIPPLES

❖

Winchester College Chapel

The lovely chapel of Winchester College is somewhat overshadowed by its more magnificent and better-known neighbour, the Cathedral. Yet the chapel is a gem, with some lovely stained glass and a fascinating set of misericords.

The cripple with the full purse on the facing page is carved with great accuracy, from the curve of the deformed right leg to the wooden blocks he uses to propel himself along.

Cripples were often depicted as creatures of contempt in many medieval illustrations since they were often beggars who had inflicted injuries upon themselves to arouse sympathy.

Perhaps the hooded, hunchbacked ape on this page, a supporter from the same seat, is meant to indicate this. Yet the main figure is carved most tenderly, which would indicate that the carver, as he was working, was moved perhaps by charity rather than scorn.

WODEWOSE

❖

St Mary's, Beverley & Whalley Abbey

Wild men or wodewose (from the Anglo Saxon *wode* – mad or wild) were said by some to represent the dark side of our nature; others say that they represent unredeemed Man. One thing is certain: the wodewose is much older than hitherto imagined and predates Christianity by at least 3,000 years. In *The Epic of Gilgamesh*, a Mesopotamian story from the third millennium BC, we read how Enkidu, the companion of Gilgamesh was a wild man covered in fur who consorted only with the animals until he took on human form after having sex with a temple prostitute.

In the Bible, Esau, 'the hairy man', is another version of the wild man and in almost every hero story the hero has a tamed wild man as his companion (Robin Hood for example has to fight and 'tame' Little John).

Many carvings of the wodewose show him wielding a club, while in others he is seen taming a lion, both of which link him with Hercules.

The carving above from Beverley shows two wild men with their clubs, flanked by wyverns. The scene opposite from Whalley shows a wodewose tamed by a lady, perhaps in itself an echo of the fate of Enkidu.

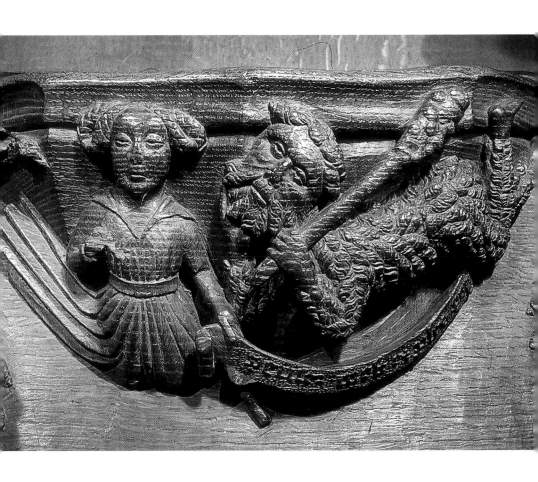

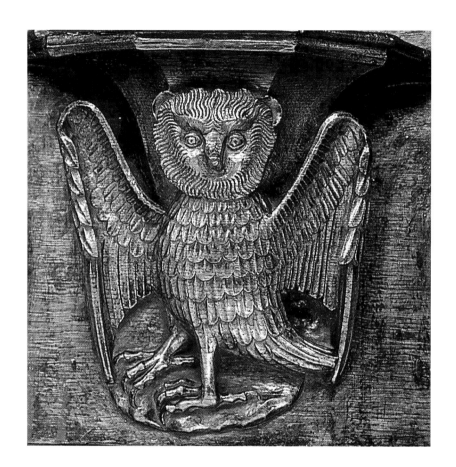

THE UNWISE OWL

❖

St. Andrews, Ludlow

The owl has not always been seen as a wise bird. Pliny saw them as harbingers of death and spoke of the 'funereal owl and monster of the night'.

By medieval times, because it shunned the light and was thought to court only the hours of darkest night, the owl was seen as a symbol of the ignorance of the Jews who shunned the light by refusing to accept Jesus Christ as the true Messiah. Owls are often shown in medieval art being mobbed by flocks of smaller, Christian birds like that on the supporter above.

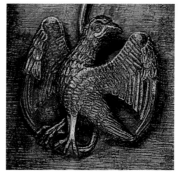

Shakespeare's Ophelia says 'Well, God 'ild you! They say the owl was a baker's daughter,' referring to the legend that a baker's daughter refused to give bread to the starving Christ and was turned into an owl for her lack of charity.

Of all the possible accusations that are levelled against this bird the strangest is the claim made by Philippe de Thaon, who wrote in a French medieval bestiary that the owl only ever flew backwards; presumably this was so that grit and dust didn't get in its eyes.

55

Mooning & Mouth-Pulling

❖

Sherborne Abbey & Tewkesbury Abbey

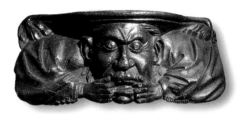

Bottom-showers, like priapic exhibitionists, are far more numerous on the continent now than they are in these islands, which leads me to suspect that the overzealous and prudish Victorian clergy did away with them in the same way that folk song collectors of the time bowdlerised every bawdy folk song they collected.

We understand now that this was the spirit of the times, but in a more liberal climate we can only lament the loss of countless rude, earthy, and openly sexual carvings, folk songs and stories.

We suffer a double loss in that, not having the evidence before us, we can only guess at both the meaning of the subjects and the climate in which they were seen to be fitting subjects for church carvings. We no longer understand that fun and bawdy humour were part of the fabric of worship. The face-puller above leers out of a carving from a lovely set of misericords in Sherborne Abbey.

The bottom-shower opposite from Tewkesbury is one of a set of crude but charming carvings in a pair of old stalls.

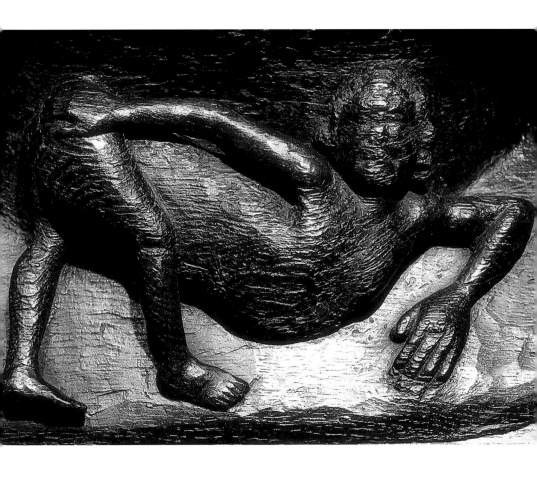

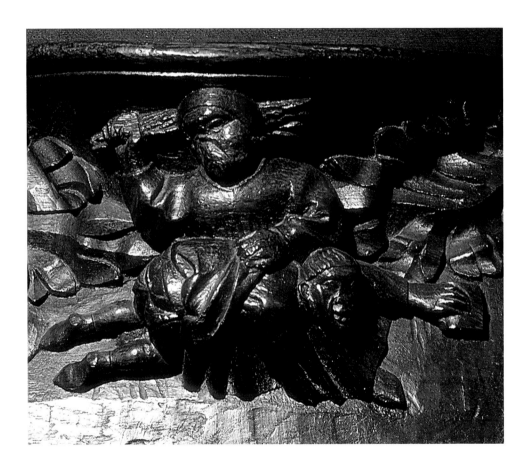

Novice-Spanking

Sherborne Abbey

One of the few carvings to show the daily life of the monks. Surely this must have been one of the most popular carvings in the choir stalls, and you can readily imagine how the younger monks would have turned it over with relish to show the novices their possible fate.

It is difficult to know how much the church encouraged carvings like this. They must surely have been against an attempt to ridicule the established church? Carvings showing quack doctors and Reynard preaching

in the guise of a mendicant friar would probably be not just tolerated but encouraged. But anything showing the clergy in a less than perfect light would, I imagine, have had the censor's blue pencil through it. The story of Tybalt and the priest's mistress (p. 44) is the only exception I can think of.

The two novices on the supporter on this page seem to be drinking and having a rather jolly time of it which may mean that before long they too will find themselves bent over the novice master's knee.

DOMESTIC SCENES

❖

St Mary's, Fairford, Gloucester

Delight in the everyday is a vital aspect of the misericord carver's art. The carving on the facing page from St Mary's Fairford shows what seems to be a courting couple having a friendly spat. He is trying to take her shoe off while she appears to be threatening him with a ladle. There is every possibility that this is about to develop into the full-scale domestic confrontation of the kind we see on pages 14–15.

On this page the seat from Gloucester shows a dog stealing meat from a cooking pot while, according to most interpretations, a woman spins with her distaff. I wonder, though, whether the scene shows that the woman has actually seen the dog stealing the meat and is striking out at it? Whatever the case, it is a charming carving and I always find it truly moving to stand and look at a scene like this, as fresh and as vivid as when the carver lifted his chisel off the wood after his last stroke and rubbed his hand over the finished carving more than six hundred years ago.

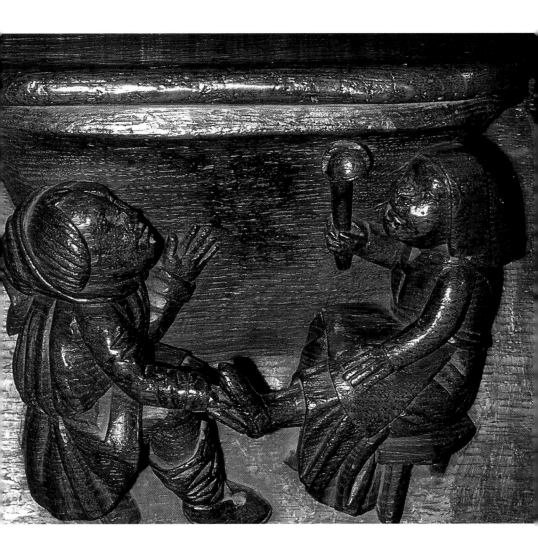

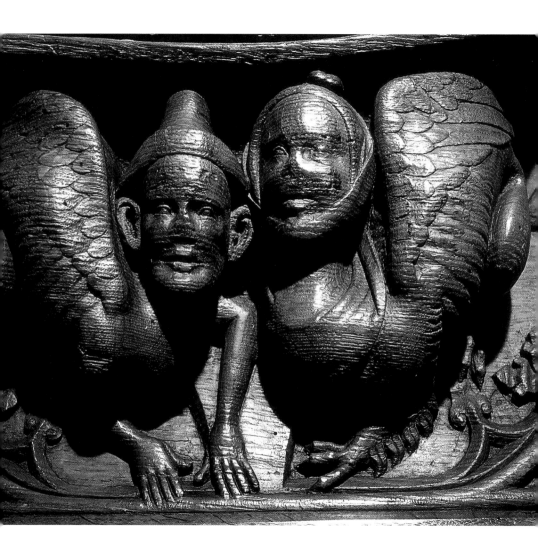

Flying Monsters

❖

Gloucester Cathedral & Chester Cathedral

Buddhist monasteries in the Himalayas are covered in wall paintings that show devils and demons often with wings. Likewise, Persian miniatures from the ninth century show winged demons preying on vulnerable souls. Assyrian and Egyptian art also has many representations of flying monsters and demons.

The ability to fly, extended also to angels and fairies, thus seems to be a root necessity for anything claiming to be otherworldly. From Garuda, the flying God of Hindu mythology, to Peter Pan and Tinkerbell, the human race has peopled the beyond with flying creatures. Whether this is an expression of an inner desire to fly or another example of what Jung would call an 'archetype' is for others more qualified than myself to argue over, but it is interesting that both evil and good take to the air for the benefit and detriment of mankind, thus both St Michael and the Devil in the form of a dragon are shown with wings.

The two friendly monsters opposite are from Gloucester, the nightmare on this page comes from Chester.

BIBLE STORIES

❖

Ripon & Bristol Cathedrals

Eve and Adam in the Garden of Paradise modestly cover their naughty bits with their hands while Satan, in the guise of a serpent with a human head, watches from the shelter of the Tree of Knowledge.

The carving on the opposite page from Bristol is one of the few that show biblical scenes, since it would appear that in general scenes from domestic life or the world of fable far outweigh stories from the Bible. Where the good book is represented at all, it is almost always by stories from the Old Testament such as the story of Jonah

on page 28. New Testament stories are more than rare – they are almost totally absent. No Lazarus coming forth from the crypt, no Last Supper, no Wise Men with their camels.

The Old Testament scenes we do have are represented quite wonderfully in these two carvings. The carving of Samson carrying off the gates of Gaza from Ripon Cathedral is a particularly well-worked piece, the perspective of the city behind is superb, and the detail is beautifully cut, down to Samson's boots and the curl of his fingers on the gate over his shoulder.

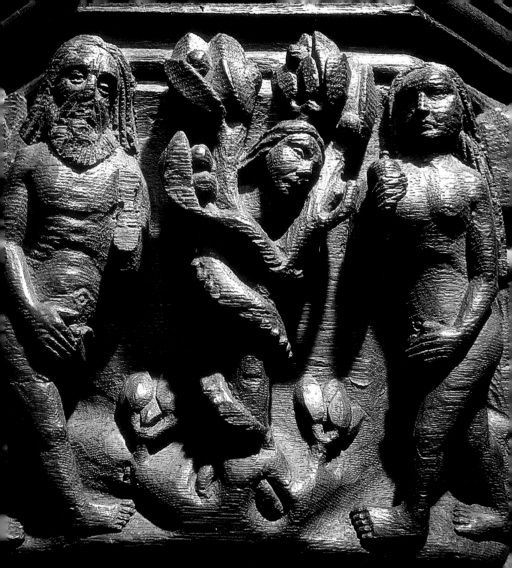

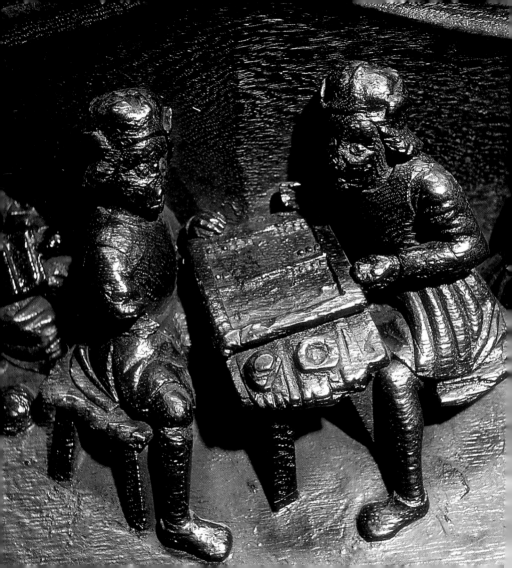

GAMES

❖

Manchester & Gloucester Cathedrals

As though to prove that life, if not all cakes and ale, was at least a little small beer and fun, the misericord carvers, from time to time, would show people at play.

The two men on the left from Manchester's great Cathedral are playing Tric-Trac, more commonly known as backgammon. Part of a set of stalls that miraculously escaped the German bombing of that city in World War II, they are beautifully carved though the women on either side, who are said to be pouring beer and carding wool, have been badly damaged.

The scene below shows two men playing what looks like football or handball. The carving is full of movement, with the moment stunningly captured by the carver's chisel. The piece also gives us a good indication of the costume of the time. The men are wearing hoods and doublets and have purses hanging down from their belts. In this way misericords teach us as much about the manners and the fashions of the time as any book or manuscript, and they are therefore invaluable both to the scholar and happy amateur alike.

My thanks go to the Deans and Chapters of all the cathedrals whose treasures are featured in this book and likewise to all the vicars, vergers and enthusiastic helpers who gave me so much assistance. Draughty churches and chapels were opened for me and people went to great lengths to light my way in the darkness. Countless ladies gave me cups of coffee and tea and, with the exception of one man who is obviously unwell, I was shown nothing but kindness and courtesy by all those involved in the care and maintenance of the churches and cathedrals they so obviously love. I offer this book as my thanks to them and in praise of the men and women who created such great art to the glory of their God.

The photographs were taken using a Nikon F3 and 20mm, 35mm and 55mm macro lenses. The film used throughout was Fuji Velvia, and I also used a small video light to illuminate the carvings.

On the left is a supporter from a misericord at Beverley Minster, an amusing topsy-turvy scene of a cat playing a fiddle for a group of dancing mice, while the Priory at Cartmel is home to the proud Eagle holding a bunch of grapes in its beak.

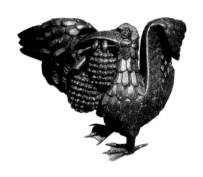

THE END